PLANNING
AND
PRODUCING
POSTERS
by JOHN deLEMOS

THE DAVIS PRESS, INCORPORATED
Publishers of the School Arts Magazine
Worcester, Massachusetts • 1943

CONTENTS

The working drawings and photographs
in this book were produced by

GORDON deLEMOS
Palo Alto, California

FOREWORD

THIS HANDBOOK on Posters has been written for those in need of concise, easily understood suggestions on planning and producing posters. All of the methods described are based on successful poster classes conducted in high schools, art schools and teacher-training groups.

Poster making is a fascinating activity. It has unusually wide possibilities and covers many art phases. No art department program can be complete without the inclusion of this practical and artistic activity.

The author wishes to gratefully acknowledge the interest and cooperation of the following:

California School of Fine Arts, San Francisco, Calif.
Chicago Academy of Fine Arts, Chicago, Ill.
Chouinard School of Art, Los Angeles, Calif.
Lord & Thomas, National Advertising Agency
Los Angeles City College, Los Angeles, Calif.
Parsons School of Design, New York City
Ringling School of Art, Sarasota, Fla.
R.C.A. Manufacturing Co., Camden, N. J.

In addition, a number of progressive high schools furnished typical posters for use as page illustrations in the book.

John deLemos

Art Director, The Latham Foundation
Palo Alto, California

Cover for a Travel Folder done in poster style *by* Gordon deLemos

WHAT MAKES
A GOOD POSTER?

When the Chinese wrote that "one picture is worth a thousand words" this statement was based on hundreds of years of experience. They knew that a message placed before the observer in picture enabled his mind to grasp the idea much more rapidly than from the printed word alone.

Along the line of art work, the making of posters is a subject full of interest to the art student, and full of possibilities from many angles. Poster designing offers splendid training along art lines, as it covers drawing, designing, lettering, and color. In addition, it helps develop a knowledge of psychology, which is a valuable asset to any educational background.

The early Chinese and Egyptians both used posters effectively in their art work hundreds of years ago. Ever since that time, posters have played an important part in the art history of all nations.

This being so, it is certainly worth while for the art student and teacher to have a fair knowledge of the points that go into the making of a good poster. The suggestions given on the following pages are based on both professional and teaching experience, and can be relied upon as being practical and effective.

Before going into the technical points connected with poster making, it pays to stop and analyze the features that are found in an attractive, convincing poster. A good way to do this is to put down the main points found in effective posters and study them.

1. A good poster should carry well.
2. It should be simple.
3. It should be interesting and attractive.
4. It must be convincing.
5. It should leave a definite message.

1. Let us suppose you are planning to make a poster. The first thing to do is to read over any wording you may have that describes or is to accompany the illustrative idea of the proposed poster. Think this wording over carefully. Now if you were confined to only three words, in stating the message in your poster, what words would you use?

With this as a beginning, you can develop the idea for your poster, both as to wording and design. Remember that in doing this the design and wording should work together in "putting over" your idea. This will help give your poster unity or "oneness" in telling its story.

2. SIMPLICITY is an essential point to work for in a good poster. There are varied ways of obtaining simplicity. One plan is to eliminate everything that is not necessary to the poster's message.

Too much lettering, lettering hard to read, fanciful borders, and unnecessary shading all help to kill a poster's simplicity. To have real simplicity and carrying power, a poster should be done in flat, decorative areas very much as if these areas had been made from cut paper.

3. AN INTERESTING AND ATTRACTIVE POSTER can be produced without destroying its simplicity. This interest may be aroused by the idea embodied in the poster. It may be developed through the type of design used or the uniqueness of the artist's viewpoint.

Pleasing composition, well-planned value arrangements, and rich color schemes all lend to the attractiveness of a poster without affecting its quality of simplicity.

4. IT MUST BE CONVINCING. Our third rule, in reality, depends considerably on the two rules which preceded it: that of simplicity and attractiveness. Yet a poster may be simple in quality and pleasing to see without having a convincing character.

5. LEAVING A DEFINITE MESSAGE is a factor very essential in posters that are attempting to "sell an idea." Let us take, as an example, the case of a poster advertising an automobile.

The poster in question may be well drawn, good in color, and attractive in appearance. It may be so general in character that it does not leave a definite message. In other words, the poster may be so planned that it might be advertising almost any make of car.

Such a poster is not usually a good one, because a short time after seeing it, the observer often has difficulty in remembering what particular make of car was being advertised. If, on the other hand, the artist had stressed some feature in his particular car, which was superior to or different from other makes, he would have left a "definite" message

All of us are familiar with the little chick and the slogan "Hasn't scratched yet!" by the Bon Ami people in connection with their cleaning powder. This ad is a good example of a close tie-up between picture and wording, and a fine example of putting over a definite message.

One plan for developing a good knowledge of poster making, is that of studying outstanding posters made by prominent artists. When you see an effective billboard, car card or publicity poster, try to figure out why you like it. Study it from the angles of composition, values and color. Then see if it "puts over" the message it is trying to convey.

This plan of analyzing posters will help considerably in building up a beginner's poster making ability.

Many current magazines have covers and advertising done in a good poster style. The best of these should be clipped from the magazine and added to your reference files. They will be found a big help in guiding you along the road to successful poster making.

Poster making is a most interesting activity and a splendid subject for school art classes. In making a poster, the artist covers composition, design, lettering and color. In addition, he needs to figure on the psychology of his poster from the standpoint of its attention-arresting value, appeal to the reader and a convincing message.

Like most arts, the ability to turn out worthwhile posters will come largely from enthusiasm, industry and perseverance.

A typical poster design planned for car card and billboard use.
Courtesy Lord & Thomas, National Advertising Agency

PLANNING
A POSTER

All of us know that good drawing is the basis of successful art work. In view of this, it is reasonable to figure that posters are much more apt to be good ones if the person making them knows how to draw.

COMPOSITION: One of the features that makes a piece of art work interesting and attractive is good composition. By this we mean the manner in which the main areas of a drawing or poster are related to each other. The direction taken by the main lines in a poster is also important.

In composing a poster sketch, the artist tries to place the essential features of his poster in the most prominent places. Some of these are indicated in the accompanying diagrams.

EYE LEVEL: In looking at a poster, the observer's gaze tends to focus first on the parts level with his eyes. This is generally a little above the horizontal center of the poster and is known as the "optical center." For this reason artists nearly always place along this optical line the part of the poster they wish seen or read first. This is an important thing to remember in connection with poster composition.

COMPOSITION LINES: Having focused the observer's eye on a main theme in the poster, the artist then tries to carry the observer's gaze from one part of the poster to the other, so that he does not miss any essential phase of the design or reading matter.

This is done by correct planning of the main direction lines of the picture. Sometimes it is accomplished by using an arbitrary direction line.

Again, it may be done by a clever "spotting" of attractive colors. At any rate, the main idea is to carry the reader's eye easily from one part of the poster to another, so that he catches the message the poster wishes to convey.

BALANCE: In planning a poster, regardless of its size, you should always try to keep its various parts so that they balance each other. Most people are unconsciously affected in a negative manner when they look at anything which is poorly balanced. Balance plays an important part in developing unity in a poster. If a poster tends to lack unity when planned in outline, this weakness can be helped by a good distribution of values or color. Often the lettering can be better placed so that it will help the poster hold together. A poster is seldom in good balance if any of its units look as if they could be moved to any other position than where they are.

Basic arrangements used in poster and advertising design

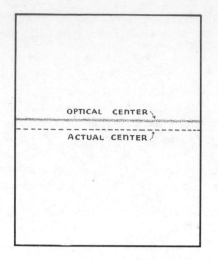

JOIN THE
SCHOOL OF RHYTHM

SKETCHING "LAYOUTS": For laying out rough ideas or "thought" sketches, a medium grade pencil and paper with slightly rough surface are a good combination. No attempt should be made to draw details, but attention should be focused on planning an interesting combination of design and lettering.

In making these rough sketches, the pencil should be held loosely, so as to permit of quick, free strokes. If a number of errors are made in a pencil sketch, it is better to start a new sketch, rather than do a lot of heavy erasing and patching on the first sketch.

VALUE ARRANGEMENTS: After making five or six thought sketches in outline, select the best three and complete them in "values." This is done by shading in certain portions dark with the pencil, leaving other areas light or the color of the paper.

Values in a poster are so important that a special chapter has been written on this subject. It is not amiss to say here that amateur posters show more weakness from the standpoint of values than any other angle.

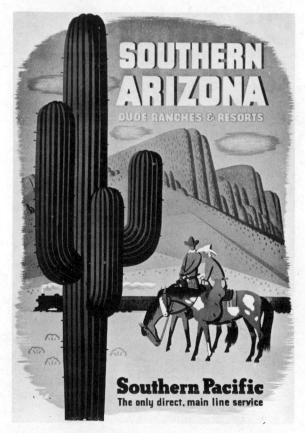

An "idea sketch" and the completed poster

DRAWING CONSTRUCTION: While modern posters are decorative in quality, good posters show a knowledge of drawing. A professional artist can make a decorative figure for a poster in which a good knowledge of figure drawing is evident in the construction of the figure.

An amateur, trying the same thing, might make use of the same decorative style, but the figure construction underlying his drawing is weak, through lack of training and experience.

One way of criticizing your sketches is to hold them at arm's length and look them over from that distance. Mistakes you might have overlooked, or possible improvements, will be more apparent if you try this plan.

TRACING PAPER: In blocking out your large poster drawing, it is the best plan to use a sheet of transparent tracing paper. Any erasing or changes necessary in your outline drawing are made on this tracing paper. This helps to preserve the surface of your poster or illustration board.

After your poster has been laid out correctly on the tracing paper, turn the paper over and run a pencil over the outlines of your sketch. Tack the tracing to the poster board and trace the outlines with a medium or hard pencil. This should give you a good, clean-cut sketch ready for painting.

ORIGINALITY: In connection with drawing and designing posters, the question of originality naturally comes up. Needless to say, the more original an artist can be, provided his work is good, the better off he will be. Professional artists form the habit of "registering" or committing to memory the essential characteristics of the common things around them so that they can draw them without difficulty. This habit is a good one and in time helps considerably to build up an artist's sketching ability.

On the other hand, it is foolish to suppose that anyone will be able to remember the details of everything he may need to draw in his art work. For this reason, artists assemble what is known as a "reference library." These references are made up mainly of clippings from current magazines, photos, prints, and similar material.

Suppose you wish to work up a poster showing a "streamline train" as the main topic. The chances are that you have a general idea as to the main characteristics of one of these trains, but are not certain as to details. Here is where your reference material comes in. With several pictures of streamline trains to look at, you can sketch in your details and know they are correct.

This same idea holds good in connection with airplanes, steamships, costumed figures, animals, and dozens of other common subjects. A good reference library saves any artist many hours of time.

PROFESSIONAL ARTISTS who receive good prices for their work, can afford to hire professional models to pose for them. If they wish to make a cover design or poster of a pretty girl playing golf, they call in a professional model, have her pose swinging a golf club, and sketch directly from their model. In this way their work becomes largely a matter of making a good painting or poster from a posed model, a method at which high class artists are adept.

PHOTOS: Unfortunately, most amateur artists cannot afford professional models and must rely on their reference library or other methods. One plan used by some artists is that of taking photographs and working from these. With a fairly good camera and knowledge of photography, this plan is a very good one.

Oftentimes you can find a friend or relative who will pose for the desired action pose and in this way you have something definite to go by. In some instances you may even work up an impromptu costume made of fabrics and clothing around the house, and in this way provide yourself with snapshots that help you produce a better poster.

This plan of using photographs from models is such a good one that many professional artists use it. It saves time and expense, and makes it easy for the model to take poses that are difficult to hold for any length of time.

VALUES IN POSTER WORK

VALUES: After having carefully planned your poster from the composition standpoint, the next important item to figure out is what is known as the "values" in a poster. Generally speaking, by values, we mean the dark and light areas found in any piece of art or poster work.

In spite of the fact that these light and dark areas play a most important part in the success of any art work, many beginners are very careless about the value arrangement of their drawings or designs. This is unfortunate, as any good artist will tell you that the value arrangement of a design or poster can make it a success or failure.

PROFESSIONAL ARTISTS have a special rule in connection with values in poster designing. This is to the effect that a good poster has the general appearance of being "a *dark*

White silhouettes against black
areas are always effective

design against a *light* background or a *light* design against a *dark* background." Briefly, the poster should be "light on dark, or dark on light."

Of course, there are some exceptions to this rule. Also, there may be parts of the larger areas broken up with lighter or darker spots, but the *general effect* should be as explained above. In other words, the poster should have good silhouette value. If poster beginners will keep this rule in mind, it will be a great help to them.

CUT PAPER METHOD: An easy way to study and figure out pleasing value arrangements is to make use of cut paper forms. After you have worked up your general composition, you can then cut out squares, triangles, circles, or other shapes from black and gray papers and use these in figuring out your values.

With the help of these cut paper forms you can readily move them around, experimenting with arrangements until you have one which you believe is effective. This cut-paper method avoids

Typical "black and white" poster arrangement

There are oftentimes posters for such sports as Sailing, Skiing, and Mountain Climbing where white silhouettes are very appropriate. Because of the fact that white silhouettes have not been used in the past as much as black ones, you should use white silhouettes when possible, in order to obtain more unusual effects.

CAST SHADOWS ONLY: This type of poster drawing is considerably harder than ordinary silhouettes, but the final results more than pay for the study you may put into it.

In making a "cast shadow" drawing, you sketch an object so that the *shadows only* are filled in with solid black. In order to catch on to this method of working, the best plan is to first copy some or all of the shadow drawings shown on Page 14 of this book. This practice will give you a more definite idea of how shadow drawings are put together.

The next step is to take one or two simple objects such as a bowl and a vase, and set them on a desk or table in such a light that the

Silhouettes are helpful in producing posters that "carry" well

a great amount of changing and erasing in cases where you try to work with pencil tones on paper.

BLACK SILHOUETTES: When you look at a dark row of trees at sunset, just as the sun is sinking, you have a good example of a black silhouette. The dark trees set against the glowing light background makes an attractive picture.

Realizing that a poster should be fairly simple to be effective, many artists make use of silhouettes in designing their posters. In silhouettes, all the unnecessary details have been eliminated. Only those features are kept which are essential to show the main character of the object or subject being portrayed. Because black silhouettes are easiest to make, those showing dark against light are most generally used.

WHITE SILHOUETTES: There are many cases where your poster will look best if a *white* silhouette against a dark or black background is used.

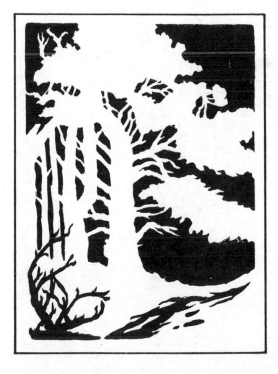

Poster arrangement featuring "white silhouettes"

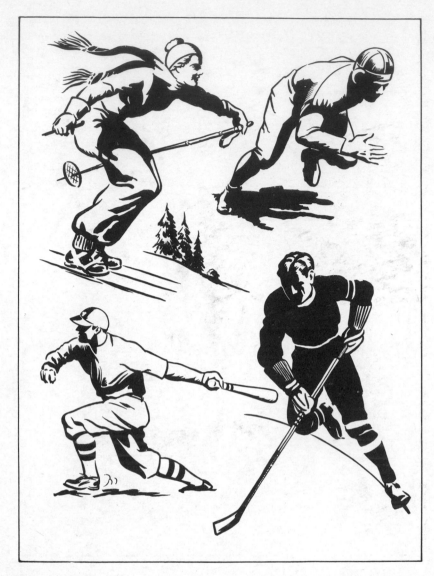

Work done "in shadow only" is the type which helps give posters punch and carrying power

shadows are very definite. Now try to draw this group in *shadows* only. It may be a little difficult at first for you to separate the definite shadows from the rest of the tones, but you will acquire this ability with practice.

One plan which helps considerably in locating the shadows is to look at objects through half-closed eyes, tipping the head slightly back. This method helps shut out the extra light. It eliminates from your vision the little supplementary shadows, leaving visible only the larger areas of light and shade.

In addition to working directly from groups of objects, you will often find prints of photographs done in such good contrast that it is a simple matter to copy them in shadows only.

HIGHLIGHTS ONLY: Objects sketched in "highlights only" are based on the same plan as shadow drawings. In this case the subject is represented by drawing only the lightest or highlighted portions of the objects.

Highlight effects are very good in posters where portraits are being shown. Glassware, silverware, and jewelry all look good when done by this highlight method.

THREE VALUE DRAWINGS: After having practiced different types of techniques, the next step is that of trying a drawing done in three values. In this case, part of the poster design is white, part of it black, and part in a medium gray tone. Drawings made in this way can be made very effective and the three tones so

It is an easy step from drawings done in shadow only to those having a medium tone or middle value

arranged as to carry well. A good way to try this is with white and black chalk on gray paper.

Confining yourself to three values helps you to keep the poster simple and decorative in style. Drawings in values may be arranged with

1. White and black on a gray tone.
2. White and gray against black.
3. Or gray and black on white.

FIVE VALUE DRAWINGS: It is an easy step to develop from working with three values to drawings having five values. In this case, the values are made in the relation shown on an accompanying diagram. As can be seen, this value arrangement is the original three-value group with an extra intervening value inserted next to the white and black tones.

A poster in five values has plenty of tone variation and allows for considerable freedom in figuring out arrangements of light and dark areas. In fact, the amateur artist will find that the three-value posters will often be superior to those having five values.

CHECKING YOUR POSTER VALUES: Those with considerable experience in judging posters have found that about thirty per cent of the posters submitted in contests are weak in their value arrangements. In many instances the lettering is practically illegible at a little distance because it blends too much into its background.

If artists would pay more attention to the values in their posters, many posters that fall short of their mark would be prize winners.

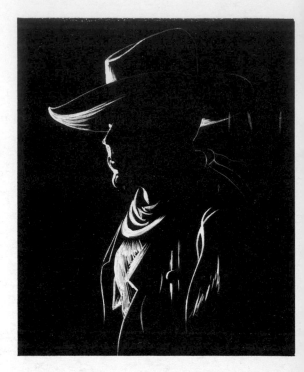

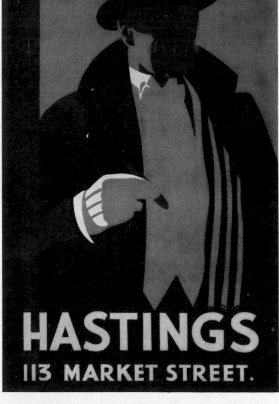

HASTINGS
113 MARKET STREET.

A strong type of poster using five values

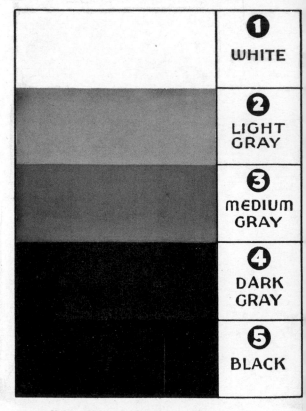

1 WHITE

2 LIGHT GRAY

3 MEDIUM GRAY

4 DARK GRAY

5 BLACK

Value charts are helpful in planning posters

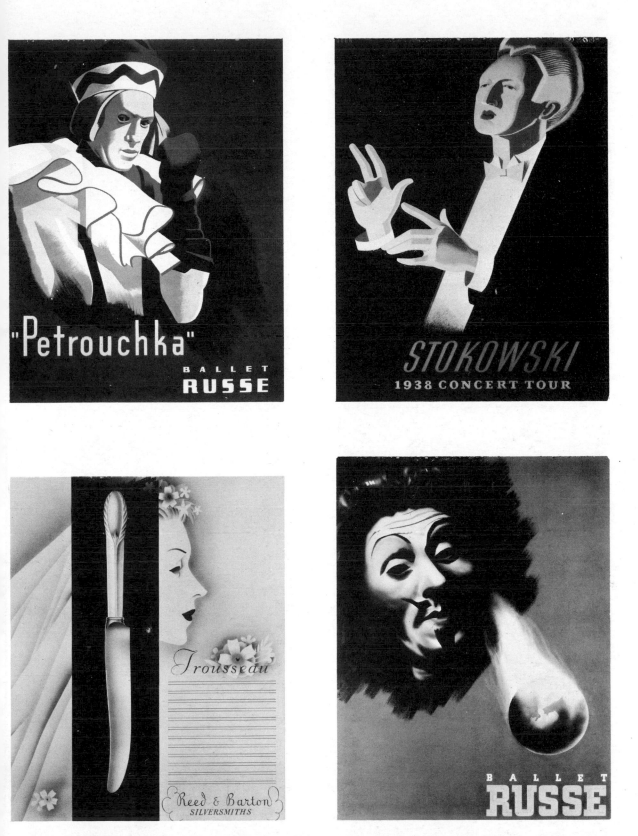

Four effective posters made by students of the Chouinard School of Art, Los Angeles, California. The two upper posters have made use of strong value contrasts. The bottom ones are more delicate in style

SUGGESTIONS
ON COLOR

COLOR IN POSTERS: Since most original posters are done in two or more colors and many posters printed in colors, it is important that a poster designer learn all he can about color.

COLOR PSYCHOLOGY: All of us are very definitely affected by our color environment. Sometimes we are conscious of our color reactions and sometimes we do not realize why we like or dislike certain objects from a color standpoint.

COLOR SYMBOLISM: Most of us have colors we prefer to others in the color spectrum. Due to this common reaction, research experts have made up a simple diagram which shows the sensation the average person associates with certain colors.

With such a diagram as basis, the color student has a good key to average color reactions. Based on such a knowledge, the artist would naturally plan to use yellows, orange-reds and browns in a poster typifying life in the tropics. On the other hand, a poster featuring a trip to the South Pole would be more appropriate done in a color scheme in which blues, blue-greens, and blue-violet predominated.

The above plan is not an arbitrary one, but gives a good basis from which to begin for the selection of color.

A COLOR WHEEL: Before attempting to acquire a color knowledge for use in poster work, it is always best to first make a good Color Wheel. In this color wheel should be indicated the standard hues, arranged in proper order for successful use and study. Making such a wheel helps you to become better acquainted with colors and their correct names. It is also a very useful aid in planning color schemes.

COLOR THEORIES: There are dozens of color theories advocated by different people. Some are based on color as studied from the viewpoint of light. In other theories, the well established basic or primary colors have been set aside and others put in their place. This has

been done in the hope of developing color wheels that will produce more lively and brilliant color combinations.

The difficulty with some of these color schemes lies in the fact that they have been worked out with light as the experimental medium. While these theories are satisfactory from the viewpoint of light rays, they are not practical when tried out with pigments such as oil paints or water colors.

SEDIMENT IN PIGMENTS: The various art pigments are made up of color mixed with a "carrying vehicle" as it is called. For instance, the carrying vehicle in a wax crayon is wax and paraffin. In oil paints, the color is mixed with white lead in order to give it body. All of these carrying vehicles contain a certain amount of sediment. It is this sediment which prevents some light-ray theories from working successfully when applied to pigments.

THE THEORIES USED BY PRINTERS: After years of experimenting, color printers and most commercial artists still make use of the well-established color theory which is based on yellow, red, and blue as the basic or primary colors. When used with pigments, this theory holds up very well.

For instance, suppose a photoengraver wishes to make color engravings for reproducing a color drawing. He first makes three engraving plates from the original by means of color filters. One of these plates has raised dots on it, showing only the yellow portions of the drawing. The second plate contains the red, and the third plate, the blue portions of the original drawing.

The printer is given these plates. He uses yellow, red, and blue printing inks, printing the three plates the engraver has made for him. He prints the yellow, then the red, and finally the blue. The resulting piece of work is a close copy of the original color drawing. All the tints, shades, and intervening colors found in the original drawing are produced when these three color plates are printed over one another. For

A USEFUL COLOR WHEEL

YELLOW

YELLOW-ORANGE

YELLOW-GREEN

ORANGE

GREEN

RED-ORANGE

BLUE GREEN

RED

BLUE

RED VIOLET

BLUE-VIOLET

VIOLET

GOOD COLOR SCHEMES YOU CAN LOCATE

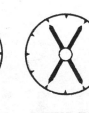

| COMPLEMENTARY COLORS | SPLIT COMPLEMENTARY | DOUBLE SPLIT COMPLEMENTARY | TRIAD COLORS | RELATED COLORS |

This Color Wheel and its accompanying indicators can be made a great help to art students in planning their poster color schemes

instance, a yellow dot found in the yellow plate, with a red dot printed over it, produces orange, or with a blue dot produces green.

This color process has proven so successful that it is used extensively in reproducing colored drawings and colored photographs.

A PRACTICAL COLOR WHEEL: Based on the above successful experience of color printers, the color wheel diagram in this book uses yellow, red, and blue as basic colors. This color wheel is used constantly in most public schools and many art schools because very attractive color schemes can be produced with its help.

To make such a wheel, the student should purchase a piece of illustration board and block in the large and small circles with light pencil lines executed with the help of a compass. When the color diagram is laid out, take tempera or opaque paints and fill in the required colors.

Along the line of tempera colors, be sure to purchase those that are pure in color and that will keep this purity, even when two and three hues are mixed together. Some cheap brands of show card or tempera paints are not carefully made and a color labeled as orange, for instance, will be found lacking in brilliancy and pureness of hue.

MAKING COLOR INDICATORS: After the necessary colors have been painted on the color wheel, the next step is to make a set of indicators that will help you figure out worth-while color schemes. These indicators should be planned to fit your color wheel and designed like those found in an accompanying diagram. They can be cut from any stiff wearable paper or thin cardboard.

COLOR TERMS: While many of us are familiar with general color terms, it will not hurt to repeat some of them.

1. Yellow, Red, and Blue, known as Primary Colors because all other colors are based on them.

2. Then we have Orange, Green, and Violet, known as Secondary Colors because each one is produced by mixing two primary

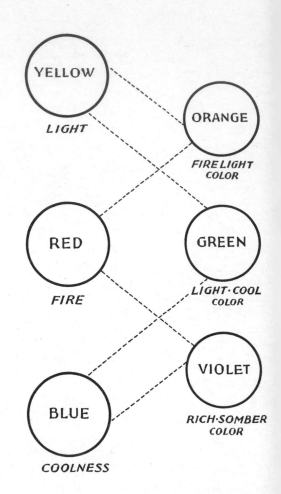

colors together. Yellow and Red mixed together give us Orange. Yellow and Blue produce Green; and Red and Blue give us Violet.

3. Tertiary is the name given to a third type of colors. These are made by mixing together combinations of Secondary Colors. For instance, if we mix together Red and Violet, we have a Tertiary Color, often known as Plum color among costume designers and interior decorators.

4. In the same manner we produce Quaternary or Fourth Division Colors by mixing four colors together. When this many colors are mixed together, soft grayed tones are produced. Tones of this kind generally make pleasing backgrounds in a poster.

There are three features connected with all color. These are known as Hue, Value, and Intensity.

HUE refers to the various kinds of colors as they are arranged on the color wheel. Yellow refers to the hue of a color, as do Orange, Blue, Green, Red, etc.

VALUE refers to the amount of dark and light a color contains, in other words, the light reflecting qualities of a color.

INTENSITY refers to the purity or carrying power of a color. Intense colors are those that strike the eye with considerable power or force. For instance, Red-Orange is a more *intense* color than Gray-Blue. When one looks at these two colors on the same poster, the Red-Orange catches the eye first and seems to stand out against the background. Gray-Blue, being a mild, soft color, tends to remain in the background, as far as its visibility is concerned.

MAKING USE OF COLOR: When making use of color in a poster, it is a good plan to remember the above-mentioned characteristics of colors. The idea in successful poster work is to place together colors that are harmonious as concerns HUE. Then from the VALUE standpoint, these colors should be either light or dark enough in value to make an attractive poster from the standpoint of light and shade.

Last, the more INTENSE colors should be used in the smaller spots and areas, or in portions of the poster you wish to emphasize.

WORKING WITH COLOR: Having made a Color Wheel, we can make good use of it. First, study the names found under the Color Indicators shown on the diagram. One of these indicators helps you to select what are known as Related or Analogous Colors.

RELATED COLORS is a name given to those sets of colors found next to each other on the color wheel. By attaching the color indicator marked "A" to the center of the color wheel, with a pin or thumbtack, you can turn this indicator in any desired direction. In doing so, the five arms of the Indicator "A" point to five different colors. These colors are known as Related Colors because they all have some common color mixed into them in varying proportions, depending on the color.

Let us suppose we have the Related Color Indicator in place. We turn it so that one arm

of the indicator points to Yellow-Green. The next arm then points to Green, the next to Blue-Green, then Blue, and Blue-Violet. Arrange them in a row. You have:

Yellow-Green	
Green	The common color found
Blue-Green	in all of these colors is
Blue	BLUE
Violet	

THE BEST USE FOR RELATED COLORS: In selecting Related Color Schemes, you will find that the colors are always in harmony. Related Colors are good where pleasing color effects are desired without too much contrast. Related Colors are often used in planning color schemes for interior decoration.

COMPLEMENTARY OR CONTRASTING COLORS are obtained by using Indicator "B." This has only two arms, which point in opposite directions. Contrasting color schemes that make use of these "combination" colors are always more pleasing than those using the straight primary and secondary colors such as Yellow and Violet, or Red and Green.

SPLIT-COMPLEMENTARY: After becoming more or less familiar with the simpler types of color combinations, we may wish to try schemes that allow for greater variation. Indicator "C" helps us produce what are known as Split-complementary Colors. "Why such a name"? you ask. Here is the reason:

In using Indicator "B" we were able to produce Complementary Colors, but suppose instead of only *two* colors, as is obtained with Indicator "B," we want *three* colors that are in close harmony. We use Indicator "C" which has a straight arrow pointer at one end and a forked pointer at the other. Let us suppose that we turn the indicator so that the end with the single arrow points toward Orange. Then we find that the forked or double end of the indicator points toward Blue-Violet and Blue-Green respectively. In this way we have located three colors, we can be sure will harmonize.

This Split-complementary Indicator can be used to obtain a wide variation of color schemes, all of them harmonious. For instance, in this

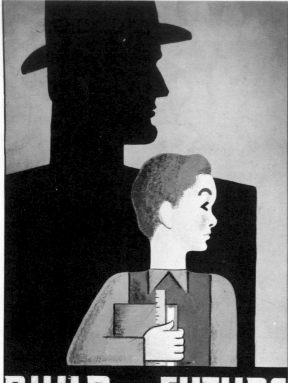

BUILD FOR THE FUTURE
COMMUNITY CHEST

1. Yellow, Green, Red, Violet
2. Yellow-Orange, Yellow-Green, Blue-Violet, Red-Violet
3. Blue-Green, Blue-Violet, Red-Orange, Yellow-Orange

With this indicator, the artist will find it an easy matter to work out four-color combinations for use in poster work.

TRIAD: A comparatively simple indicator is the one marked "E." This has three pointers, radiating from the center in the form of a triangle. By means of this indicator, Triad Color Schemes, or those based on sets of three colors, are located. However, while three colors are obtained with the Split-complementary Indicator, they are not the same as those found when using this Triad Indicator. The Triad Indicator locates colors which are set at regular intervals from each other on the Color Wheel.

way we can locate the following good color combinations:

1. Red, Yellow-Green, and Blue-Green
2. Green, Red-Orange, and Red-Violet
3. Yellow, Red-Violet, and Blue-Violet

DOUBLE SPLIT-COMPLEMENTARY COLORS: Having tried out the Split-complementary Indicator, we can go a step farther and make use of a Double Split-complementary Indicator. This one (marked "D" in the diagram) has two pointers at each end, making it possible to locate *four* colors at one time, all of which are in harmony.

In our experiment with this indicator, suppose we turn two of the arrows so that they point at Orange and Yellow. Then the other two arrows point toward Violet and Blue. So with this indicator we are able to locate *four* colors, all of them harmonious. Other Double Split Color Schemes, figured out in this manner, would be

Two well-planned posters made by art students at Los Angeles City College, Los Angeles, California

If we turn one arrow to Yellow, the others point at Red and Blue, which covers all three primary colors and is a somewhat strong color combination. Turning one arrow to Orange, gives us Violet and Green as the other two colors. This combination is more pleasing than the first one, and is always artistic. Other Triad Color Schemes are:

1. Yellow-Green, Red-Orange, and Blue-Violet
2. Yellow-Orange, Blue-Green, and Red-Violet

So with the simple Color Indicators shown, and a well-made Color Wheel, an artist can quickly locate color combinations that he can use as the basis for his color work.

TINTS, SHADES, AND GRAYED COLORS: So far, in selecting color combinations, we have been referring to them from the hue or color standpoint only, without any mention of tints or shades. All carefully manufactured colors are made so as to be standard or normal as concerns the amount of color found in them.

A TINT OF A COLOR is produced by adding white or clear water to a normal color. You are using opaque or tempera, then you add white tempera to a color to produce a tint of that color. *Tints* are always *lighter* in value than their normal colors. If you are using water colors, you add clear water to the color to make a tint of it. Clear water makes the water color more transparent, reducing its color content.

SHADES of colors are made by adding black to normal colors. If you have a Green, for instance, and wish to make it deeper in tone, you mix a little black into the Green. This plan is used with both opaque or transparent colors. *Shades* are always *deeper* in tone than their normal colors.

SUBDUED COLORS: Let us suppose that we have a poster for which we have already selected the brilliant and normal colors. Now we want some pleasing color which is just soft or subdued enough to make a good background color.

This color can be produced in a number of ways. You can take two secondary colors,

Good composition, well-planned values and a touch of humor make this poster an unusually good one. From Los Angeles City College

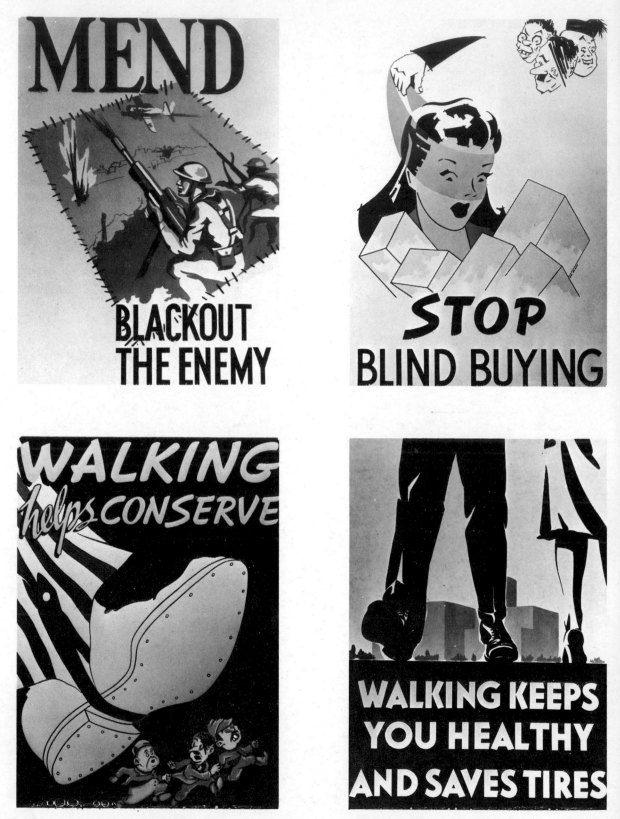

Art students are interested in patriotic topics these days. Above are four outstanding posters designed by students at the Chicago Academy of Fine Arts, Chicago, Illinois

Green and Orange, and mix these together to produce a Tertiary Color commonly known as Olive among printers and painters. If you mixed together the two Secondary Colors, Orange and Violet, you would produce a Red-Brown which makes a good background color.

After an artist becomes accustomed to using color, he will often mix four or five colors together to make a certain soft "off-shade" as they are called. In cases like this, it is important to mix plenty of color for your needs, because it is difficult to match these "off-shade" colors, unless you have kept a record of the amount of each color used in the mixture.

SATURATION is a method often used by artists where they wish to make sure of close harmony in the colors they plan to use. Say, for instance, an artist has five colors lined up for use on his poster. In painting strips of these colors, on a piece of paper to test them out, he decides that his Green and Orange do not seem to quite harmonize.

An easy way to bring these two colors into harmony is to mix a little Orange into the Green, or, if the Orange hue is too strong, mix a little Green into the Orange. This plan tends to "Saturate" one color with another so that they harmonize better.

This same plan can be used with three, four, and five colors. If you are planning to use, say four colors in a poster and wish to make sure they will look harmonious, try mixing a little of one of the colors into all of the others. In most cases you will find that this plan helps considerably.

GENERAL SUGGESTIONS: In time you may not need to refer to the Color Wheel in arriving at successful color schemes. Your knowledge of color and trained eye will be all you need to help you put together pleasing color combinations. At the beginning, however, it certainly pays to rely on your Color Wheel.

For those who wish to purchase them, several art supply companies have correct Color Wheels printed in black outlines on good water color paper. You can buy one of these and paint the necessary colors in each of the printed outlines. This gives you a good, serviceable Color Wheel for all-around use.

And don't forget! Be sure to buy tempera colors that are made in accurate color palettes. One art manufacturing company has spent years of research and thousands of dollars perfecting color materials that are 100% accurate in color sequence. When you work with paints like these, you are much more certain of success.

A clever effective billboard design, courtesy Lord & Thomas, San Francisco, California

POINTERS ON
LETTERING

Good lettering forms one of the most important features of a successful poster. When one comes to analyze it, letters are in reality a series of small design motifs arranged so as to convey a message. If the amateur letterer will learn to think of letters from the design standpoint, this will be a great help to him in producing high class lettering.

As many people know, our first alphabet came down to us from the early Egyptians, who kept their records by means of story symbols or "ideographs" as they are called. In order to make these records easier to produce, the Egyptian priests simplified ideographs, so that they could be made rapidly.

The early Phoenicians, who were a great nation of traders or merchants, adopted the Egyptians' ideographs and made them into an alphabet which could be used to facilitate their business transactions. In turn, the Greek and Roman nations made use of these alphabet symbols, changing them to meet their individual requirements.

It is from the classic Roman alphabet that we base the letters we use today in our present printing and artistic lettering. These classic Roman letters were very painstakingly designed, so as to be highly artistic, and for this reason are still used extensively in many forms of art and architecture. The accompanying illustration shows the interesting development of our alphabet from the early Egyptian story pictures.

AN EASY WAY to study lettering is to buy some of the paper having cross-ruled lines on it. This paper is used by engineers and architects, and can be obtained at almost any art or stationery store. Select the alphabet you wish to study and copy it with single strokes done with a pencil having a large, soft lead.

In this way you soon become acquainted with the construction of the alphabet you are copying and, before long, can sketch it from memory.

LETTER COMPOSITION: You will find that the proper grouping or arranging of your letters into lines or panels, is one of the most difficult parts of lettering. Try to think of each letter as a small design motif, rather than part of an alphabet.

Successful designers always watch the *background areas* left by the letters as much as they do the letters themselves. In other words, the *spaces left between the letters* catch the eye also, and should be considered in planning an artistic group of lettering. This idea is particularly important in poster work, where lettering plays such an important part.

BEGINNERS in lettering often find it helps to sketch in the *first and last* letters in a word or line of letters, right at the start. They can then space the remaining letters of the wording more readily.

In blocking in lettering, you will find that some letters such as the letter "I" require less space than the so-called "standard" letters. On the other hand, letters like "W" and "M" take up more space horizontally. For this reason, you should always read over the words you are planning to letter, so as to figure on the varying widths of letters.

While a great many styles of letters are found in posters, most of these alphabets are strong and bold in appearance. This is natural, since posters are made to be seen at a glance, and any lettering used on them should be easily read at a reasonable distance.

VARIATION IN LETTERING: A good poster artist always thinks of his lettering from the standpoint of design motifs and makes the wording an integral part of his poster. If there are just a few words on the poster, it may be best to hold to one size and type of lettering. Where there are several lines of lettering, it often helps to make the letters in one line different in size from the rest.

Again, an artist may wish to give emphasis

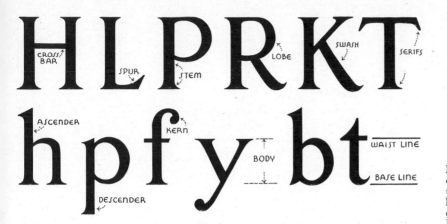

ABOVE ARE SHOWN THE NAMES OF VARIOUS LETTER PARTS

Poster art students should become familiar with the terms used in describing various letter parts. Two ways to produce white lettering against black backgrounds are also shown

to a certain word or group of words. He can do this by

1. Increasing the size of the letters.
2. Making the letters heavy and massive in appearance.
3. Using an attractive or unique type of letter.
4. Using a rich or brilliant color.

ARBITRARY SPACES: One of the problems which often confronts a poster or commercial artist is that of fitting lettering into arbitrary spaces. There may be several long words to fit into a short space horizontally. In this case, the artist "condenses" his letters. In other words, he makes them quite narrow compared to their height, so that they will keep their necessary prominence.

In other cases, there may be plenty of room horizontally, but not much space vertically. In order to keep his letters prominent in this instance, the artist "extends" his letters, making them wide horizontally, but shortening their height.

This extending or condensing of letters is a big help in planning lettering for varied areas, and can be easily done without hurting the appearance or character of the letters.

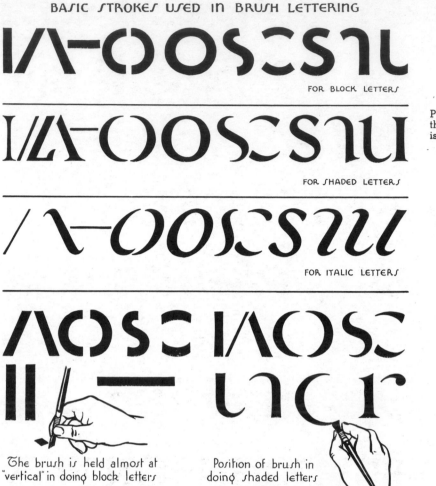

FOR BLOCK LETTERS

FOR SHADED LETTERS

FOR ITALIC LETTERS

Practice with a brush and these basic lettering strokes is bound to improve your lettering technique

The brush is held almost at "vertical" in doing block letters

Position of brush in doing shaded letters

LETTERS HAVE CHARACTER just like anything else. Certain types of letters go well with posters advertising articles like heavy, massive machinery. In this case, a bold, strong letter would be the most suitable. On the other hand, a poster featuring a dainty Easter costume will look better if the lettering used is not too heavy and of such a character that it matches the design.

Even if the wording on a poster needs to be "light faced" in character to match the spirit of the poster design, it can be made large enough so that it is easily read.

Once the artist begins to acquire the ability to block in and execute lettering, he will find both fascinating and worth while. There is a great amount of lettering being done right along in the commercial field, even during periods of depression. The artist who can do good lettering will find many demands for his services.

The beginner will find it much easier to work with a pen than a brush, because the pen point is rigid and permits the artist to focus on the direction of his strokes. In using a brush, however, the artist has two things to control. One is the shape of the letters he is making. The other is his pressure on the point or end of the brush. If he varies this pressure too much one way or another, he finds himself making strokes that are not uniform in width.

BUY JOHNSON NOW

buy JOHNSON now

BUY *JOHNSON* NOW

Many variations of the same wording are possible by changes in the characteristics of the lines of lettering

buy JOHNSON now

BUY *Johnson* NOW

BUY JOHNSON NOW

buy JOHNSON *now*

BUY JOHNSON NOW

This is one of the main reasons why it pays an amateur letterer to study lettering *first* with the help of round lettering pens. After he has acquired a certain amount of hand control through this plan, he can then begin using lettering brushes.

HANDLING BRUSHES: At the start, the best plan is to become familiar with the way the brushes work by making practice strokes with them. Hold the brush nearly vertical and try making a series of parallel vertical strokes. Then try some at a slant and a set of horizontal ones.

After practicing straight lines with the brush, try curves and parts of curves. You will find these more difficult than the straight strokes. When you have made a good number of curved strokes, try making some of the curved letters. To do this, combine several curved strokes together, being as careful as possible to have these strokes join together evenly. This last is important and worthy of practice.

In working with lettering brushes do not hold them too tightly. Hold the brush loosely enough so that you can *twist* or *roll* the brush handle between your thumb and fingers in making round letters like the "O" and "Q."

CONDITION OF PAINTS: Much of the success of brush lettering depends on the condition

of the paint. It pays to purchase well made, standard tempera colors. These are always finely ground, permitting the color to flow readily from the brush.

If the paint has too much water in it, it will run down or "puddle" at the ends of the lettering strokes, and in some cases dry unevenly. If the paint is too thick, it sticks to the brush and shows ragged edges at the ends of the strokes.

By a little testing, you will soon learn to keep the paint just liquid enough so that it flows readily from the brush, but dries with a clean, sharp edge. To do this, an opaque paint should be slightly tacky, or almost on the verge of drying, like thick cream.

LARGE LETTERING: When the lettering is quite large in a poster, the best plan is to outline it with pencil. Then go over these outlines with a medium size brush, filling in the outlines with a large brush. This is the most practical plan for those who have not had a great amount of lettering experience.

Oftentimes, however, the lettering is to be done over an area that has already been given a coat of light green, orange, or some other color of tempera. In this case, it does not pay to attempt to block in the letters directly onto the painted surface. Naturally, the repeated pencil marks and erasings that attend blocking in will mar the surface and spoil its appearance.

TRACING LETTERS: Where lines of letters are to be done over painted tempera backgrounds, lay a piece of tracing paper over the space that is to be lettered. Figure out where your letters are to go. Then place the tracing paper over a sheet of white cardboard and block in your letters on the tracing paper.

LIGHT LETTERS OVER DARK AREAS: For some reason, many amateur poster artists have an idea that there is only one way to produce light letters against a dark background. This is to outline the letters in pencil and then paint the dark background around them, leaving the letters in the light value. While this plan is sometimes used, it has one drawback. This is the fact that it is difficult for many students to paint the dark background in even tones around the lines of lettering.

An easier way to obtain light letters against dark areas is to paint the dark color on *first*. Allow this to dry thoroughly. Next, block in your letters on tracing paper and trace them onto the background. Then fill in these letters with the light color, using it fairly thick so that it covers thoroughly the dark color under it. This is the method used by practically all professional artists.

If cheap tempera paints are used, it may be found that the light colors tend to "bleed." That is, the light color is not opaque enough and some of the dark color comes through it to the surface. However, if good, reliable brands of colors are used, the colors will not bleed, but the light colors will stand out clearly against the darker ones.

VALUES IN LETTERING: In doing lettering on a poster, always be sure that the value arrangements are well planned. By "values" is meant the contrast of light and dark tones in a poster. Quite often, we see amateur posters in which the lettering is well done and properly spaced. On looking at the poster from a short distance, the lettering does not carry well and seems difficult to read.

In cases like this, you will find that the lettering is too similar in tone to the areas surrounding it. By making these letters lighter or darker in tone, you will find that they will immediately become more legible.

1234 56789

123456789

123456789

123456789

1234567890

123456789

123456789

Good sets of numerals are always valuable to poster designers.
This page illustrates a wide variation of attractive examples.

ABCDE
FGHIJK
LMNOP
QRSTU
VWXYZ

A good poster letter should be pleasing in appearance, legible and have carrying quality.
This alphabet is popular with poster artists because it fills the necessary requirements

abcde
fghijk
lmnop
qrstuv
wxyz&

The small or "lower case" letters of an alphabet are often useful in poster designing.
The letters above are designed to go with the "upper case" letters on the opposite page

ABCDE
FGHIJK
LMNOP
QRSTU
VWXYZ

This alphabet, known as Neuland, has proven very popular with poster designers. It is artistic, easily read and fairly easy to execute

34

abcde
fghijk
lmnop
qrstuv
wxyz&

Both the large and small letters in the Neuland alphabet are used extensively
by poster designers. Art students should plan to memorize this artistic alphabet

COMPLETING
THE POSTER

Many amateur artists are so anxious to start painting their posters that they do not make sure they are properly drawn before they go ahead. No matter how much color one uses on a piece of art work, it will not conceal the fact that it is poorly drawn, if the artist is inexperienced or unwilling to put the proper time into the drawing phase of his work.

COLORING THE POSTER: Let us suppose that the poster sketch has been carefully blocked in on the poster board, and that it is all ready to color. The first thing to do is to select the colors you need and mix up the necessary amount of each color. It is better to have too much color mixed rather than too little. This is particularly true of background color. Often a beginner in poster making will mix up a special color made up of two or three colors and start to use it, only to find that he has not mixed quite enough. Then when he tries to match his first color, he finds it a difficult job.

In painting the poster, it is best to paint in the larger areas first, allowing them to dry, while you go ahead with other art work. Artists with considerable art experience, paint around their outlines with quite a wide chisel brush—say a ½-inch or ¾-inch brush. They also use this brush for painting in their backgrounds. Working with a large brush helps you work faster and insures smooth tone as far as technique goes.

If the artist is a beginner, whose hand control is not well developed, he can paint around his outlines with a No. 8 show card brush. This method is quite easily done and is used considerably by many artists.

While it is not absolutely necessary to wait until the larger painted areas of color dry before going ahead with other coloring, this plan is the best. Tempera colors always dry lighter. If you allow the first colors to dry thoroughly, you can then plan subsequent colors more accurately so as to produce a more perfect color scheme.

CHECKING COLORS: As you proceed with your painting, be sure to set the poster up some place where you can see it at a distance, to check on the colors. You will often find that colors which appeared quite brilliant at close range are not strong enough to carry at a distance.

If you have a Diminishing Glass, take a look at the poster occasionally through this as you are working on your poster. These glasses make the objects seen through them look smaller. You will often find that faults in values or color schemes that you have not noticed, will be readily apparent when you look at the poster through a Diminishing Glass. After the main colors have been painted, then the smaller spots and details should be added.

There are cases where a light color is to be painted over a darker one to indicate one or two lines of lettering. In this case, white tracing paper should be placed between the original poster sketch and the panel on which the lettering is to appear. The lettering is then traced in white outlines onto the dark panel. Next, mix your light color so that it is fairly thick and paint inside the white letter outlines. If the paint you are using is a good standard make, this light colored lettering should dry sufficiently opaque so as to completely cover the dark panel of color under it. This is the best way to paint letters against a dark background.

Sometimes amateur artists produce light lettering against dark panels as follows: First, they paint in the light letters with a medium size brush. Then they paint the dark color around the light lettering also with a medium size brush. This plan is not bad but is slower than the other method.

KEEPING COLORS CLEAR: One point which helps the appearance of a poster considerably is that of keeping colors clear and crisp in appearance. To do this, it is necessary to have several glasses of clean water always available and to wash the poster brushes in this water quite often. Try to keep one or two brushes for special use in the lighter colors such as white and light yellow. Other brushes can then be used for deeper hues, such as violet and blue.

Another point to remember is *not* to dip a colored brush into a second color in order to remove some for use in color mixing. The right way to use color is to remove what color is needed with the help of the little mixing sticks that come with standard sets of tempera paints.

USING COLORED PAPERS: Most professional poster artists make use of colored or toned board or papers in making posters. In this way they have a smooth, even tone on which to work. This method cuts down the amount of time and effort involved in making a poster.

MAKING YOUR OWN COLORED BOARD: Sometimes an artist has in mind a certain color or shade that he cannot obtain in the manufactured poster board or papers. In this case, the best plan is to mix up the necessary amount of the color you have in mind, pouring it into a wax paper cup. Thumb-tack board or paper down and paint the color on with a wide, soft brush.

In order to obtain a smooth, even tone, paint the color on with even, horizontal strokes that just lap each other. Then, before the color dries, turn your drawing board and drag the brush lightly across the strokes you have just painted, going at right angles to the first set of strokes.

POSTER BOARD VS. PAPER: Illustration Board is so named because it is popular with artists who draw illustrations for magazines and newspapers. It comes in different thicknesses and consists of a well-made paper with a good surface which will take pencil, ink, water colors, or tempera equally well. This paper is pasted onto a heavy cardboard backing so as to keep the paper smooth and firm. Illustration Board is very good for poster work and is used considerably by artists for posters.

USING THE BRUSHES: Remember to keep your colors in good shape by stirring them in your mixing dish occasionally. A good plan, also, is that of pressing the brush up against the edge of your mixing dish in order to squeeze out surplus color before you begin to paint with it. This plan also smooths out the hairs of the brush so that they fall into the right position to work properly.

In using the larger background brushes, it is a good idea to paint with one side of the brush and then turn it over and paint with the other side. This helps to use up all of the color in the brush before you dip it into the color again.

MAKING STRAIGHT LINES AND BORDERS: Amateurs are often surprised to see the ease with which professional show card and poster artists draw straight lines and borders on their posters. This part of poster making is quite simple once you understand how it is done and have practiced it for a while.

The trick in making straight lines with a brush lies in the way the fingers are held against the edge of the drawing board, ruler, or other straight edge you are using as a guide. The last three fingers of the hand are held rigidly against the straight edge. The brush is held rigidly by the thumb and first two fingers when the straight line is being drawn.

The stroke is made almost entirely from the elbow and shoulder, always remembering to keep the hand rigid. If the fingers are allowed to move too much, or slip from their position, the ruled line will be uneven and "wobbly." It is surprising how easy it becomes to rule these brush lines, after you have given this idea a little careful practice.

In ruling border lines, the edge of the poster or drawing board can be used as the straight edge. In making straight lines in other parts of the show card or poster, a long ruler or a maul stick make a good straight edge. In this case, the ruler is held in place with the left hand and the brush work done with the right.

CONTRASTS: Remember to keep the value contrasts in your poster quite strong. Good contrasts give a poster "punch" and character. Weak contrasts nearly always spoil the carrying quality of a poster. When a poster is photo-engraved and printed, you will find that these processes have a tendency to soften or dull the contrasts found in the original poster.

For this reason, always make the contrasts, in posters that are to be engraved, a little sharper than you need them in the completed piece of work. Then, when your drawing is finally engraved and printed, you will find that the values will be just about right.

Frequent use of the Diminishing Glass will help you know where to add bright highlights and shadows in order to snap up your poster.

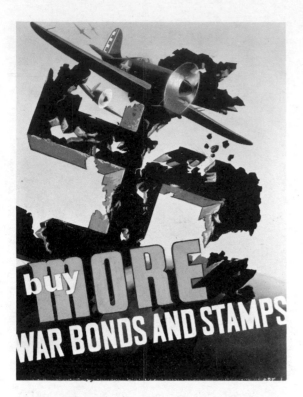

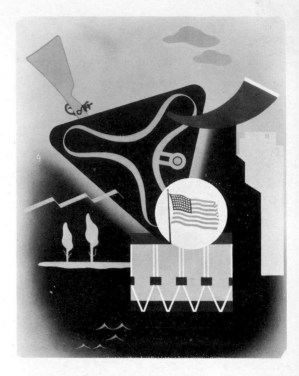

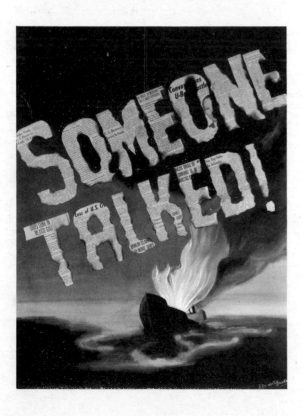

Two patriotic type posters done in vigorous modern style. These were designed by students of Parsons School of Design, New York City

Two more fine posters from the Parsons School. The one directly above leaves a very definite impression which is the aim of all successful posters

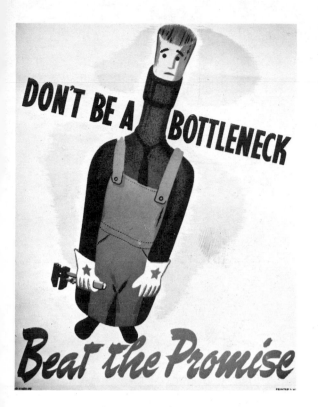

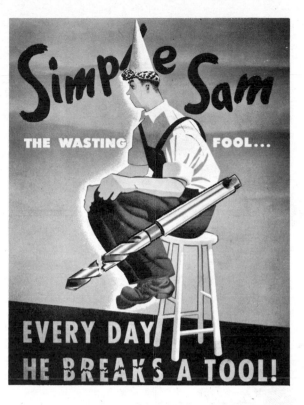

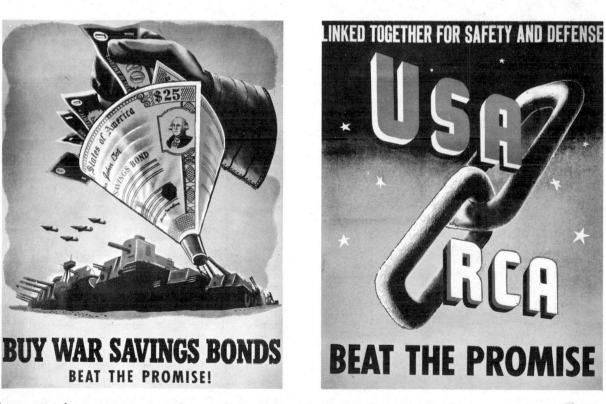

Large national organizations are quick to see the possibilities of well-planned posters. The four outstanding posters on this page were used to accelerate production in the plants of the Radio Corporation of America. They have also been extensively used in their magazine advertising

SPATTER
POSTERS

A type of poster technique which is increasing in popularity is the kind known as Spatter Posters. This technique is known as "spatter" because the tones are produced by spraying or spattering hundreds of little dots over the surface of the paper.

HOW TO PLAN A SPATTER POSTER: While it is not absolutely necessary to cut stencils for use in Spatter Posters, most of these posters are made with the help of stencils. After the poster idea has been figured out, the next step is to decide what parts of the poster are to be made with the spatter dots.

PLAN 1: In some cases, you may wish to spatter only the background, in order to produce a stipple technique in the background of the posters. This effect is very easy to produce. First, lay long strips of paper around the edges of the poster so that the spatter dots will not cover the outside margin of the poster. These paper strips can be held in place with pins or thumb-tacks.

The spattering is done with the help of a medium size insect or garden spray. Any desired color of opaque tempera is placed in the glass container, taking care to make the color thin enough so that it will not clog the nozzle of the spray.

The poster to be spattered is placed on a desk or table at a slant, and the color in the spray gun is sprayed onto the poster background until it is the strength of tone desired. It is best not to hold the spray too close, or to force too much color onto the poster at one time. If desired, the poster and stencil can be tacked to a drawing board and set up against a wall for the spraying.

If the spatter dots show an inclination to puddle, or run together, it is best to allow the spatter to dry before adding additional color. After the finished background has dried, you can then go ahead tracing the rest of your poster design onto this background and finish it with your opaque colors and brushes.

PLAN 2: Another type of poster is one in which you work on a sheet of paper which is already in color. You may select a medium gray-green sheet of poster paper on which to work. In this case, the main design itself and probably the lettering also, are cut from stencil paper, just as in making stencil posters.

These cut-out stencils are used as masks in doing the spatter work. The cut-out stencils are pinned to the poster in such a way as to keep the spatter dots from the spray gun from reaching certain parts of the poster.

In the case of our spatter poster against a gray-green background, we may decide to spatter the design in dark blue and the lettering in white. The use of our cut-out stencils and insect spray makes the application of the colors comparatively easy.

PLAN 3: In this method two or even three colors may be sprayed over the same area to give a two-tone effect. Or, as in the case of a sunset sky, several bands of different colors may be sprayed across the sky and blended together where the dots overlap.

While this method is an interesting one, care must be taken not to overdo the blending possibilities of spatter work. Too many blended colors give the poster an old-fashioned appearance which detracts from its poster qualities.

Reviewing the various methods that are possible through spatter work, we have:

1. Posters where spatter dots are used in the background only.
2. Posters in which spatter designs are made against a colored paper background.
3. Two-tone or blended effects in poster areas, produced by spraying one color over another.
4. Posters in which all of the colors are applied by means of spatter work.

DUPLICATE POSTERS: Once the stencils are cut and the color schemes figured out, it is

Two attractive "spatter" posters made by student at
the Ramsey Junior High School, Minneapolis, Minnesota

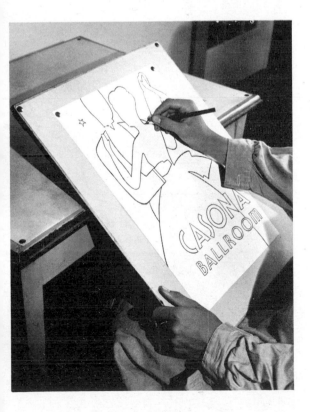 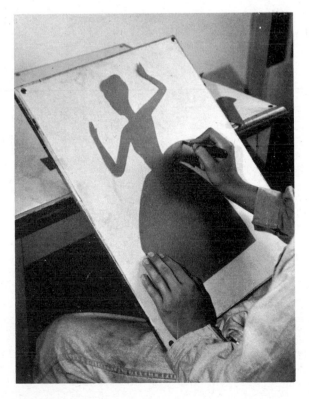

First, patterns are sketched on white paper and stencils cut
from them for use in making the popular "spatter type" posters

quite easy to produce any number of duplicate posters. The spray gun helps to cover areas quite rapidly and the finished posters are distinctive in appearance. By using poster boards of different colors and varying the color schemes, posters that are quite different in appearance can be turned out.

FOR SCHOOL ART CLASSES: Spatter posters are a good problem for school art classes wishing to work in a technique that is different from the regular type of painted poster. In addition to the poster work itself, very artistic poster panels can be made by pinning decorative plants or flowers onto toned paper and spattering the background around the flowers with opaque colors. After the spatter color has been applied, the flower or plant is removed, leaving an artistic silhouette pattern against the spatter background.

Decorative panels made by this method can be used in flower posters, for florists' window cards, and in many other useful ways.

CARE OF SPRAY: After being used, the spray gun should be washed out well under running water so as to remove all traces of opaque color from the glass container and the nozzle of the spray. Otherwise, the nozzle will become clogged with dry color and refuse to work properly.

In using color in the spray, you may find that the color fails to come through the nozzle readily. If this happens, first make sure that the nozzle of the spray is clean. After this, if the color still fails to flow freely, then the chances are that it is not thin enough. Adding a little water to the color generally solves the difficulty. A few drops of glycerine added to the paints also keeps them from drying out too rapidly.

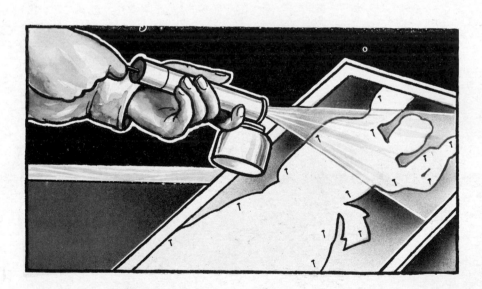

SILK SCREEN PRINTING

In recent years there is one method of reproducing posters which is rapidly increasing in popularity. This is the process known as Silk Screen Printing. Although methods similar to this have been known and used for years in the Orient, it is only in recent years that this process has become really popular in this country.

One of the reasons for its popularity lies in the fact that the Silk Screen process makes it possible to print quantities of artistic posters at a comparatively low cost. Many high schools, colleges, and art schools have installed these Silk Screen outfits as part of their art and vocational equipment.

DESCRIPTION OF PROCESS: The Silk Screen process is a method whereby colored inks or paints are forced through the meshes of a silk screen to print designs and lettering on cards and posters. Outside of the silk screen and paints, the other main item is a flat piece of rubber known as a Squeegee. This is mounted in a wooden handle and used to squeeze or force the paint through the mesh of the silk.

Because of priorities, manufacturers have developed reliable substitutes for both the silk and rubber. For those who plan to make their own printing equipment, it will be found that organdy cloth makes a good substitute for the silk. A flat piece of hard wood makes a very workable squeegee.

MAKING THE SCREEN: Where one wishes to make his own outfit, he should build a serviceable screen as shown in the accompanying illustration. Be sure the screen is made so that the corners are at accurate right angles. The fabric is best attached to the frame by tacking it on as shown in the sketch. If the cloth is soaked in warm water a few minutes before tacking it will dry smoother.

For printing cards and the average material, the screen works best if it is attached to a pair of hinges. By this plan one person can operate the printing readily.

PREPARING THE SCREEN: While there are a number of methods by which the design can be attached to the screen, the simplest and most practical is one sometimes referred to as the "Block-out" Method.

To use this method, one should purchase screen printing supplies from any good art supply company:

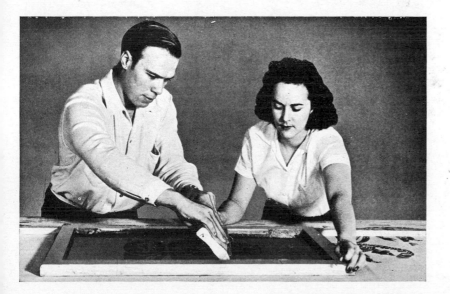

Silk Screen Printing is rapidly growing in popularity. It has wide possibilities in the production of duplicate posters

ROMA *California* WINES

ACKNOWLEDGED AMONG THE WORLDS FINEST

Posters like the one above are especially suitable for reproduction by the popular Silk Screen Process.
This poster was designed by Edmond Gross, San Francisco School of Fine Arts, San Francisco, California

DESIGNER INK: For tracing designs onto the silk screen.

SURFACER POWDER: To fill in the screen between the mesh of the cloth, so as to insure sharp lines and edges in the design.

BLOCKOUT SOLUTION: For painting the design onto the screen.

NEGATIVE LIQUID: This is used for covering the silk background around the painted design.

HOW TO PROCEED:

1. The design is sketched onto thin paper and its outlines traced onto the screen. These are then gone over with the Designer Ink.
2. Next, with a wide brush, give the screen a coating of the Surfacer Powder which has been dissolved in water.
3. Rest the edge of the frame on the knees and paint in all parts which are to print. Use the Blockout Solution for this painting.

4. Give the *inside* of the screen a coat of Negative Solution. Pour it along the top edge of the screen and allow it to flow down toward the bottom. Make sure it covers all of the screen thoroughly. Scraping a strip of cardboard lightly over the surface of the wet negative solution will result in a more even coating.
5. When the Negative Solution is dry, turn the screen over and hold the reverse side under running water. Rub the design briskly with a soft brush. This dissolves the Blockout Solution, leaving the design in the clear silk. Be sure to wash out all of the Blockout Solution.
6. With a soft cloth, dry the screen on both sides. Paste strips of electricians' tape around the inner edges of the screen, so as to seal the edges thoroughly. This plan prevents the printing ink from seeping out at points not covered by the Negative Solution. The tape holds up better than will gummed paper.

These instructions may seem a little involved at first glance, but they are in reality quite simple if each step is followed correctly, as explained.

THE PRINTING PROCESS: Various types of inks and paints are used in printing with silk screens. There are on the market special oil type paints and lacquers planned for silk screen work. These are especially good for cards or signs that are to be exposed to weather. Manufacturers of oil paints and lacquers also make special liquids that can be used to thin the printing inks or retard their drying tendencies.

TEMPERA OR OPAQUE COLORS: For general school purposes and for indoor signs and cards, tempera colors make an especially good medium. Tempera paints have the following good qualities:

1. They dry very quickly which makes for easy handling.
2. Tempera prints have an unusually attractive printing surface texture.

3. Tempera colors are quickly and easily washed from the screen with water after the printing is finished.
4. Being opaque, tempera colors make it possible to make silk screen prints in a dozen or more colors. This process is described later in the chapter.
5. With a good set of tempera colors, it is possible to mix up an almost unlimited number of artistic colors. This greatly increases the possibility of your color schemes.

A MIXING MEDIUM: To facilitate silk screen printing with tempera, manufacturers have perfected a "mixing medium." If one part of this mixing medium is added to one part tempera color, a perfect silk screen ink is produced. This medium can be purchased at any good art supply company. For best results, this mixture should be just thick enough so as not to drip off the edge of the squeegee. If it is too thin, the printed impression will not be even in tone and sharp at the edges.

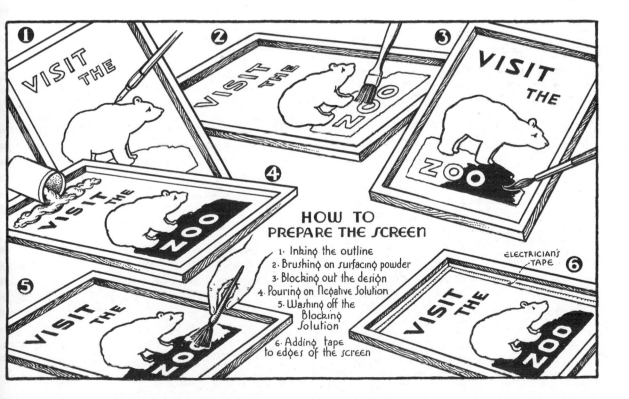

HOW TO PREPARE THE SCREEN

1. Inking the outline
2. Brushing on surfacing powder
3. Blocking out the design
4. Pouring on Negative Solution
5. Washing off the Blocking Solution
6. Adding tape to edges of the screen

ELECTRICIAN'S TAPE

STEPS IN PRINTING:

1. Mix one or more parts of the mixing medium with one part of any desired color of tempera. With a spoon, spread a good amount of this mixture along the far end of the inside of the printing frame.

2. Place your paper under the screen, lower the screen over the paper and slip the squeegee in back of the printing mixture. Hold the squeegee at an angle of about 60° from horizontal. Pull the squeegee slowly and firmly toward you until it reaches the lower edge of the frame. Then lift the screen slowly from the paper.

3. If your ink and pressure are right, your print will appear clear and sharp. White specks or light areas indicate that the ink was too dry or the printing pressure too light.

4. If, for any reason, the mesh of the screen should clog and fill up areas, take a wet sponge and clear out these areas with a little water. Dry the screen with a soft cloth and it will be ready for further printing.

PRINTING IN SEVERAL COLORS: A simple way to produce prints in two or more colors is as follows:

1. First, a sketch is done in tempera colors as a guide. Decide how many printings will be needed to duplicate this color sketch by the screen process.

2. In painting the design on the silk screen, follow the method as previously explained for one-color prints. However, in this case, leave *all* of the picture area in the *clear* silk, covering the surrounding background only with the Negative Liquid.

3. When ready, paint the *lightest* color in your design first, using tempera colors and mixing medium. When this first color has been run off with Negative Liquid, paint over all of the areas in the screen in which this *first color* is to *appear* in the *finished print.*

4. Now print the second color found in your sketch. When this is done, block out on the screen those areas in which your *second color* is to appear in the *finished print.* Use this procedure until all of the necessary colors have been printed.

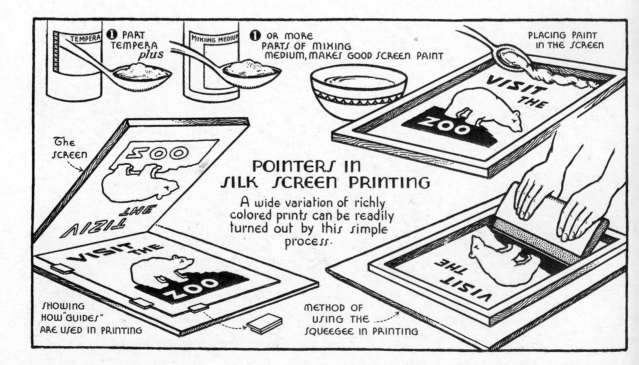

POINTERS IN SILK SCREEN PRINTING

A wide variation of richly colored prints can be readily turned out by this simple process.

This simple plan makes it possible to make silk screen prints in many colors. Tempera colors, being opaque, make it possible for you to print one color over another without difficulty.

COLOR GUIDES: To make sure that the paper or cardboard, on which the printing is being done, is placed in the right location, craftsmen use stiff paper "guides" as shown in the sketch on page 46. These guides are tacked or glued down on three sides of the paper's location, so that each successive sheet of paper can be slipped into the same identical position. Color guides insure faster and more accurate printing.

FUTURE OF SILK SCREEN: Many high schools and art schools now have Silk Screen outfits. This fascinating process has wide possibilities, particularly where duplicate posters, signs, or display cards are desired. Posters printed by Silk Screen have a pleasing quality which makes them outstanding as an art production.

A poster planned for Silk Screen printing by Gordon deLemos

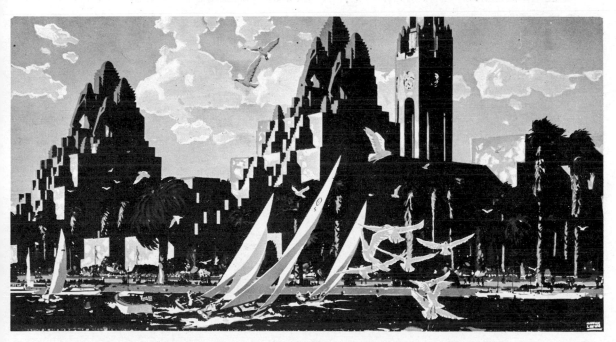

An outstanding silk screen poster designed by Maurice Logan, California artist, and printed by the Velvaton Company of San Francisco, California

A poster in which the air-brush was used
extensively to produce the desired results

Artistic poster designs made by high school students. Upper and lower left posters from Central High School, Minneapolis,
Minnesota. Upper right—Mount Pleasant Senior High School at Providence, Rhode Island. Lower right—Central High School
at Muskegon Heights, Michigan

AIR BRUSH
WORK

As time goes by, we find an increasing number of artists interested in the possibilities of the Air Brush as used in various forms of art. This is because Air Brushes make it easier for the artist to cover surfaces. They also make it possible for him to produce tone effects that cannot be obtained in any other way.

There are two main types of Air Brushes. One is the comparatively large Air Brush that may be used in turning out large commercial signs and window cards and posters. Some of these may also be used in spraying enamels on furniture and similar types of handcraft.

The other Air Brushes are those known as "pencil size." These Air Brushes are all about the size of a short, fat pencil and are capable of producing the highest type of drawing and shading. Brushes like these are used extensively in retouching photographs and making illustrations of automobiles, machinery, and similar objects where smooth, graduated tones are necessary.

HOW THEY WORK: All Air Brushes work on the same principle. They have a cup or color holder which contains the liquid that is to be sprayed onto the drawing. This is attached to the barrel of the Air Brush. This barrel is also attached to a rubber hose through which air is forced into the Air Brush, and out the end of the brush. The barrel of the Air Brush also contains a needle, the point of which fits into a small hole at the end of the brush.

As the needle is pulled back gradually by a lever, the air in the Air Brush rushes out through the small hole at the end of the brush and at the same time sucks some of the color from the color cup along with it. This color falls onto the drawing in the form of a fine spray composed of thousands of minute dots invisible to the eye without the aid of a magnifying glass. This is the principle by which all Air Brushes work, and it is a very simple one.

An inexperienced artist will find that it requires considerable skill and practice in order to operate an Air Brush successfully. However, a little conscientious study and practice for three or four days will result in some real progress along this line. Once you have mastered the use of the Air Brush, you will find it a most valuable help in many types of commercial and poster art.

HOW TO OPERATE IT: The Air Brush is held in the same way as holding a pen or pencil. While the brush should be held firmly, it should be held in a slightly relaxed manner, as this will help you work more easily.

The tip of the index finger rests on the lever of the Air Brush and is used to regulate the flow of air through the brush. When you press directly downward, only air is released through the brush. With the lever pressed down, you then begin to pull backward on it. As soon as you do this, color begins to spray out from the end of the brush. The farther back you pull the lever, the more color it releases.

WIDE AREAS AND DEEP TONES: Wide areas in your work are covered by holding the Air Brush spray farther away from the drawing. Deep tones are made by spraying several tones over each other until a deep value has been obtained. A little practice will show you just how far you can go successfully along this line.

FINE LINES are produced by pulling the lever back only a short way and holding the tip of the Air Brush fairly close to the paper. Making these fine lines requires quite a bit of practice and cultivation of hand control.

Care should be taken not to hold the brush too close to the paper. This generally results in spatter effects. In starting an Air Brush line, it is best to swing the arm in the general direction of the stroke once or twice to figure out the swing of the line. Do this with the lever pressed down but not pulled back. Then, when you have this stroke figured out, pull the lever back slightly as you begin the stroke and this should result in a smooth, even Air Brush line.

MASKS IN AIR BRUSHING: The beginner in Air Brush work should make considerable use of stencil paper masks in turning out drawings or posters. When masks are used, the beginner does not need to worry so much about regulating fine lines and directions. His main job is to spray even or graduated tones in the areas where they are needed. The paper masks take care of the excess color.

There is on the market an especially fine grade of stencil paper which is very transparent, slightly oily, and easy to cut. It also lies flat on the drawing after being cut out. Paper of this kind is best for air-brush mask cutting, as it gives you dependable guides in your air-brushing.

After being cut out and placed on the drawing paper the masks should be held down with transparent tape, small lead weights, or in some similar manner. Care must be taken to hold the edges of the masks down securely, as the air pressure from the hose has a tendency to force

Planning the poster by "blocking in" outlines only

up the edges of the stencil paper and allow color to spray under them into places where it is not wanted.

Professional artists also make use of two types of material that are popular for masking parts of air-brush drawings. The first of these is ordinary liquid rubber cement. This rubber cement is painted over the area which is to be protected and allowed to dry. The air-brush work is then done. When this is completed, the rubber cement coating is readily removed by rubbing it lightly with a small piece of kneaded eraser. The rubber cement peels off very easily without affecting the paper beneath it.

Many air-brush artists also make use of what is known as frisket paper. This may be purchased from any good art supply house. The paper is laid over the area to be protected and pressed down with the tips of the fingers. This causes the

under side of the frisket paper to adhere to the surface under it. The frisket paper is then cut with a sharp knife so as to leave covered only the parts of the drawing that are to be protected. The surplus frisket paper can be readily lifted away from the drawing. After the air-brushing is done, the frisket paper may be easily removed by lifting it slowly away from the drawing surface.

AIR PRESSURE ON BRUSH: To insure best results, it is necessary to keep the air pressure on the brush uniform and up to a certain pressure. The best pressure for all-around work is about 25 pounds. If the pressure is too high, the air has too much force. As a result it is almost impossible to regulate the tones produced with the brush.

If the pressure is too low, the color fails to flow from the cup smoothly and, as a result, the air brush "spits" and sprays coarse dots onto the paper. If the pressure is irregular, the lines and tones are uneven and fluctuate too much in tone value. A good, even pressure on the hose is an important point in air brush work.

Applying tones with the help of an air-brush

CARE OF BRUSH: Aside from learning how to use the brush, the most important item is the care of the brush. Since the air brush is capable of producing very fine lines and delicate tones, it stands to reason that its mechanism is delicate. This means that an air brush should have special care at all times. Here are some good pointers in this connection:

1. Never use cheap, coarse paints in your air brush. Use only those that are finely ground and with enough liquid so they will not harden and clog up the brush.

2. After you are through using the brush, run clear water through the color cup and finally a little denatured alcohol. Doing this will lengthen the life of the brush and keep the Air Brush clean for the next piece of work.

3. Be sure that the point of the Air Brush needle is sharp and that the nozzle into which it fits is not clogged with old paint. If the needle is dull or the nozzle choked up, the Air Brush will either spit a coarse spray or fail to spray any color at all.

Adding details to the air-brush drawing with tempera on a small brush

4. Keep your Air Brush in its case, away from dust and exposure. Do not allow amateurs to experiment with it, unless you are working with them. Lending your Air Brush to anyone generally results in a "headache."

OTHER MASKS: If you wish to practice with the Air Brush in order to master the technique, try cutting out strips of paper with irregular or geometric edges and use these as movable masks to produce varied design patterns. This practice will develop hand control and also help you develop useful patterns.

SUGGESTIONS: More trouble has been caused by poor care of the Air Brush than any other point. If the Air Brush parts are kept clean and the colors used in them are of a high grade, you should have no trouble with it mechanically.

In order to have consistent air pressure, most artists buy tanks containing Carbonic Gas. These are attached to the Air Brush Pressure Gauge and hose, and will produce all the air pressure needed. Some artists buy a small motor, air pump, and tank, and use this to obtain their air pressure. When the air pressure is low, they start up the motor which soon has the pressure up to the point needed.

The Carbonic Gas tanks are sold by local firms that supply them to soda fountains. The motors and pressure tanks are sold by national art supply companies. Both of these methods of obtaining reliable air pressure are good ones.

FREE-HAND HEADS AND FIGURES: While most figures and designs are made with the help of masks, it is possible to execute a complete head or figure entirely with the Air Brush. It takes good hand control and some practice to do this, but professional Air Brush operators can do it quite easily.

The main objection to this method lies in the fact that the completed work has a tendency to look too soft and "mushy" in appearance. A good knowledge of the Air Brush and also of figure drawing are essential to best results. Sometimes a free-hand figure which looks too soft in appearance can be snapped up with decorative lines done by hand with a water color brush.

COLORS: Since the colors used play such an important part in good Air Brush work, be sure to buy those of a high standard. For the finer type Air Brushes, color manufacturers have on the market paints especially designed for use in the Air Brush. The better grades of show card or tempera colors also work well in air brushes, if diluted with water. Using them too thick will clog the barrel and nozzle of the Air Brush.

Air Brush work can be done in any colors desired simply by changing the color placed in the color cup.

IN POSTER WORK: Where artists are expected to produce highly artistic effects with a fair degree of speed, an Air Brush is of exceptional value. Most professional poster artists keep a supply of standard masks on hand and use these in turning out any rush posters. Where time permits, special mask designs can be developed and used.

Graduated backgrounds, distance effects and similar results are quickly obtained with the help of the Air Brush.

IN SCHOOLS: Quite a number of high schools and art schools already have or are planning to purchase Air Brush outfits for their classes. Realizing the value Air Brushes have in professional studios, progressive teachers know that a knowledge of this process will be of value to young artists who plan to become professionals.

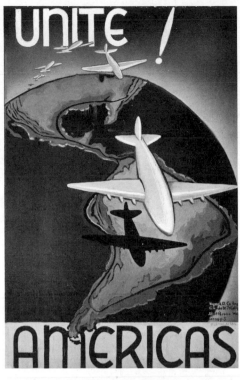

By Virginia D. Colby
Glendale Junior College, Glendale, California

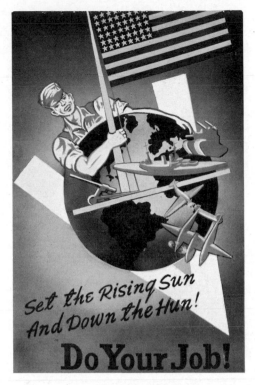

By Carole Louise Hagedorn
Moore Institute of Art, Philadelphia, Pennsylvania

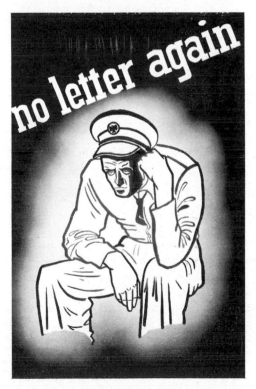

By Frank Interlandi
Chicago Academy of Fine Arts, Chicago, Illinois

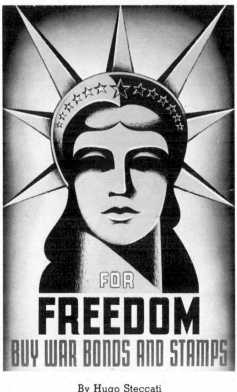

By Hugo Steccati
U.S. Naval Reserve, Oakland, California

Typical Air-brush Posters Entered in the Latham Foundation Victory Poster Contest

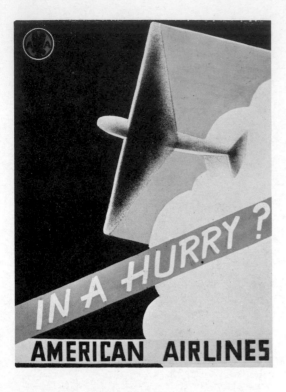

Four attractive posters from the Ringling School of Art, Sarasota, Florida.
These show a wide range of both poster topics and technique